PAISLEY
MANDALAS
COLORING BOOK

DESIGNS WITH A SPLASH OF COLOR

SHALA KERRIGAN

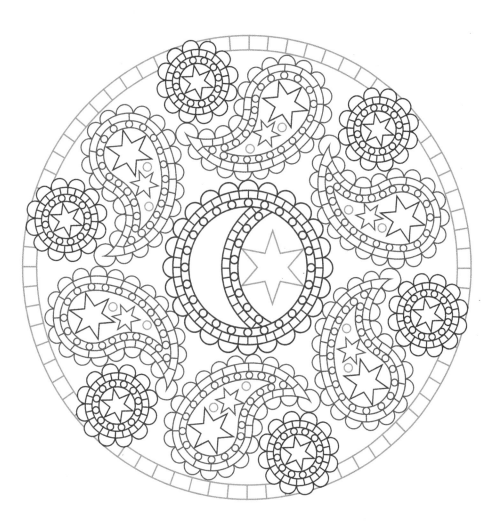

DOVER PUBLICATIONS, INC.
MINEOLA, NEW YORK

Combine ever-popular mandalas with paisley patterns and behold the attractive results! Stars, butterflies, flowers, fish, and other cleverly concealed elements add to the beauty of these images. In this latest edition to Dover's *Creative Haven* series for the experienced colorist, thirty-one intricate patterns will delight artists and colorists of all ages. The versatile designs have been outlined in vivid hues, providing a unique opportunity for experimentation with different color combinations. Plus, the perforated pages make displaying finished work easy!

Copyright

Copyright © 2015 by Dover Publications, Inc.
All rights reserved.

Bibliographical Note

Paisley Mandalas Coloring Book: Designs with a Splash of Color, first published by Dover Publications, Inc., in 2015, contains all the plates from *Paisley Mandalas Coloring Book,* originally published by Dover in 2014.

International Standard Book Number

ISBN-13: 978-0-486-80535-1
ISBN-10: 0-486-80535-2

Manufactured in the United States by Courier Corporation
80535201 2015
www.doverpublications.com

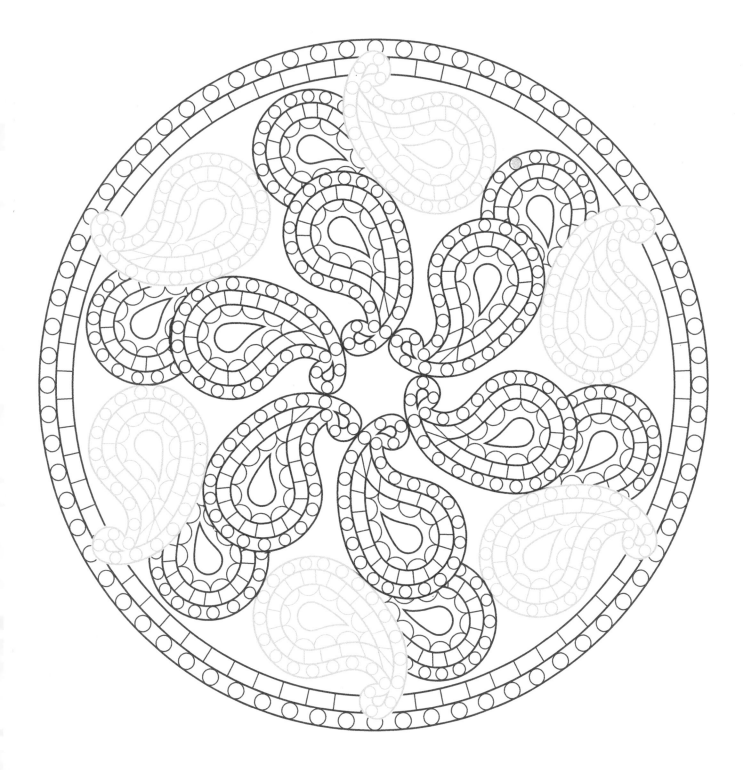

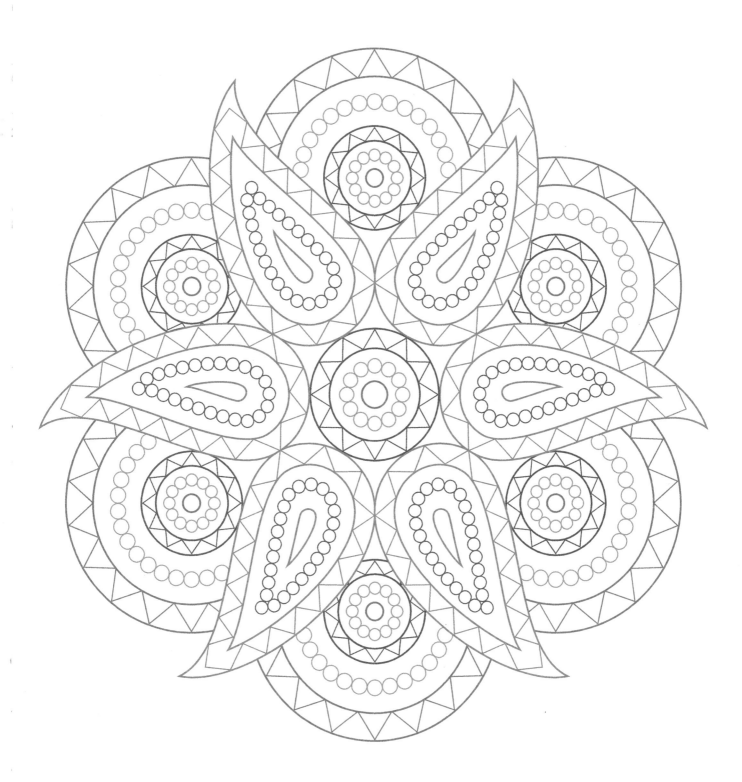

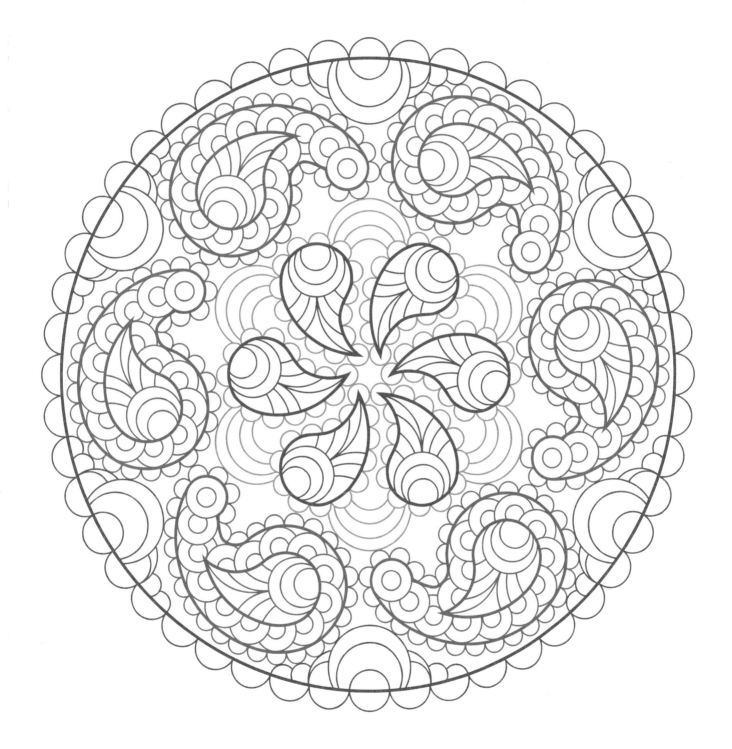

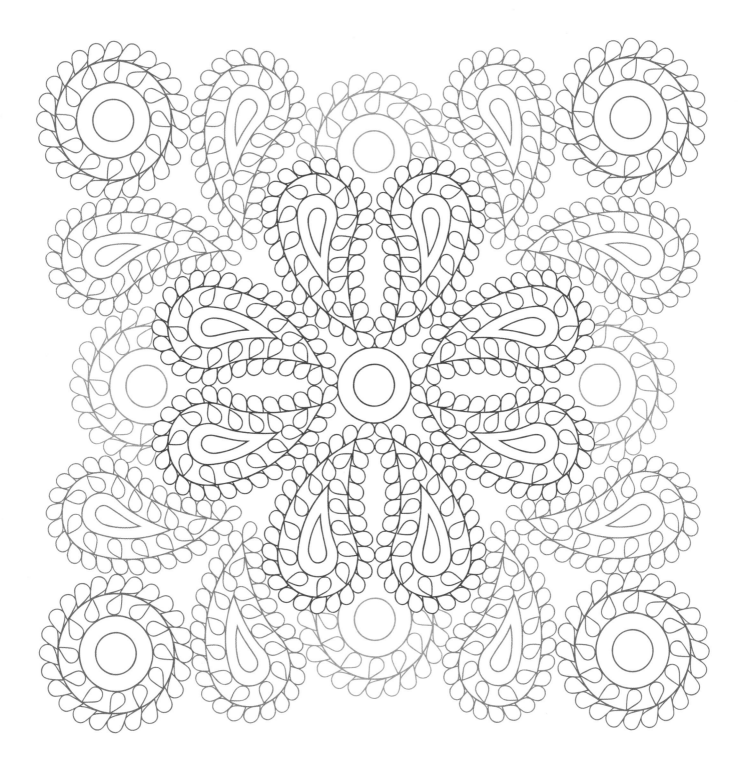

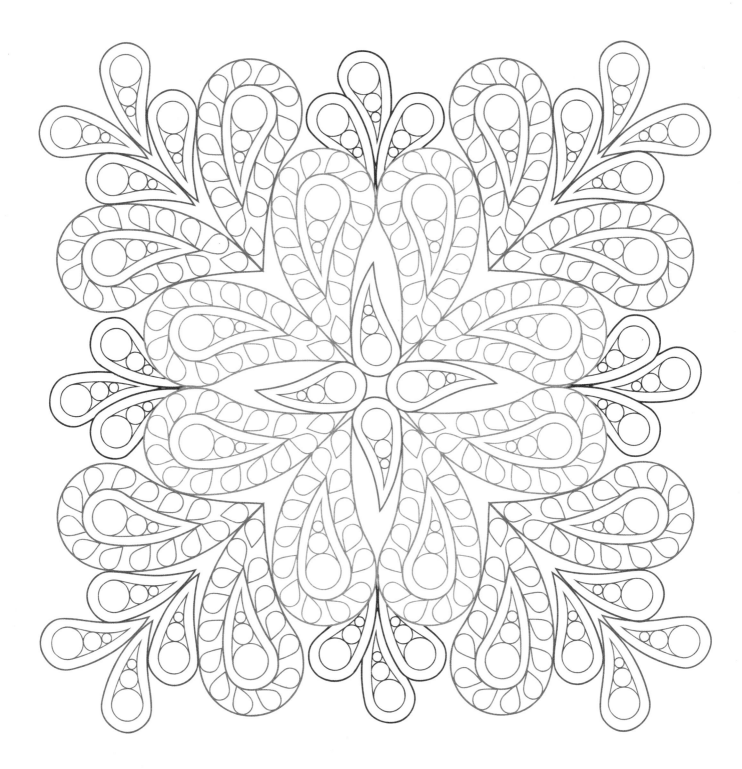

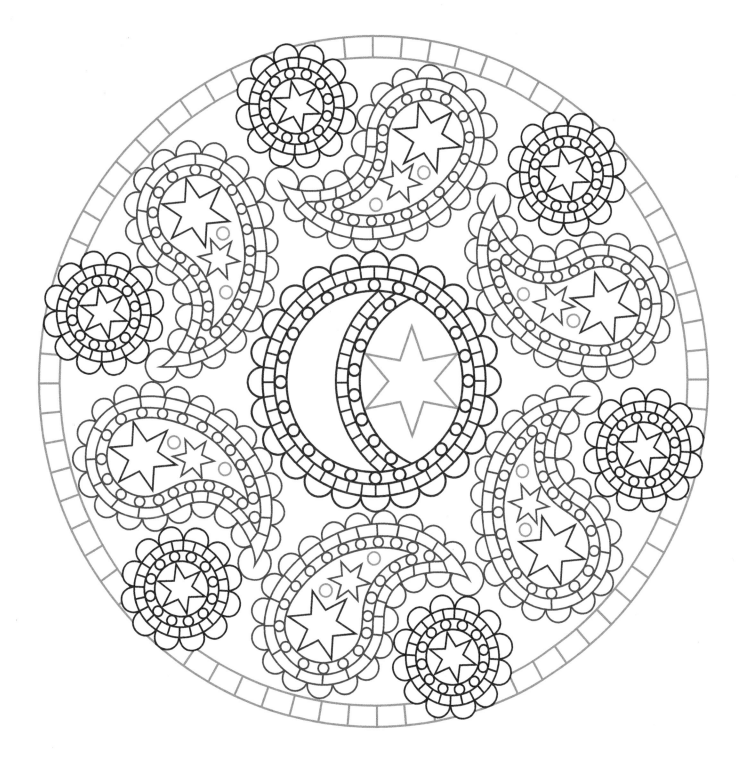

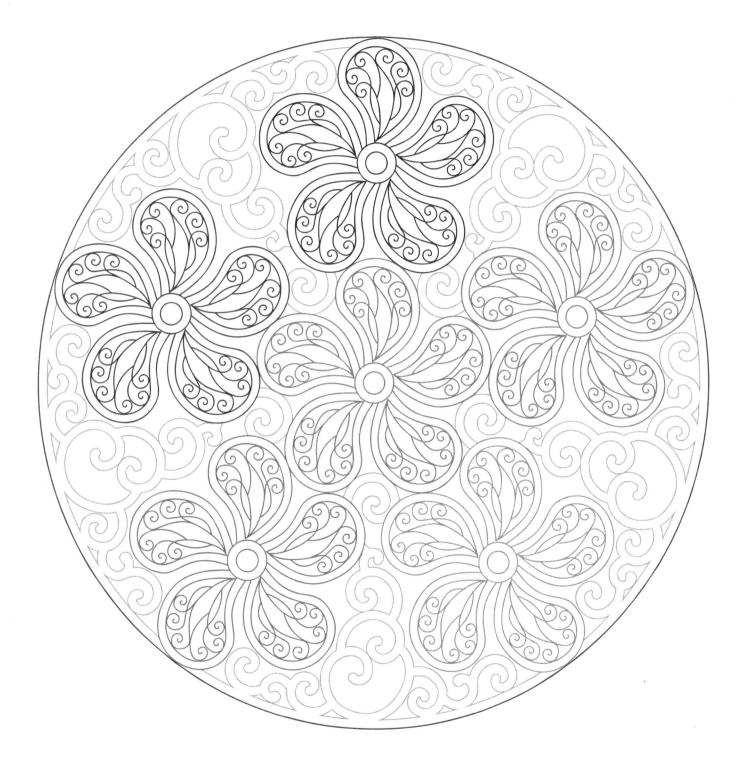

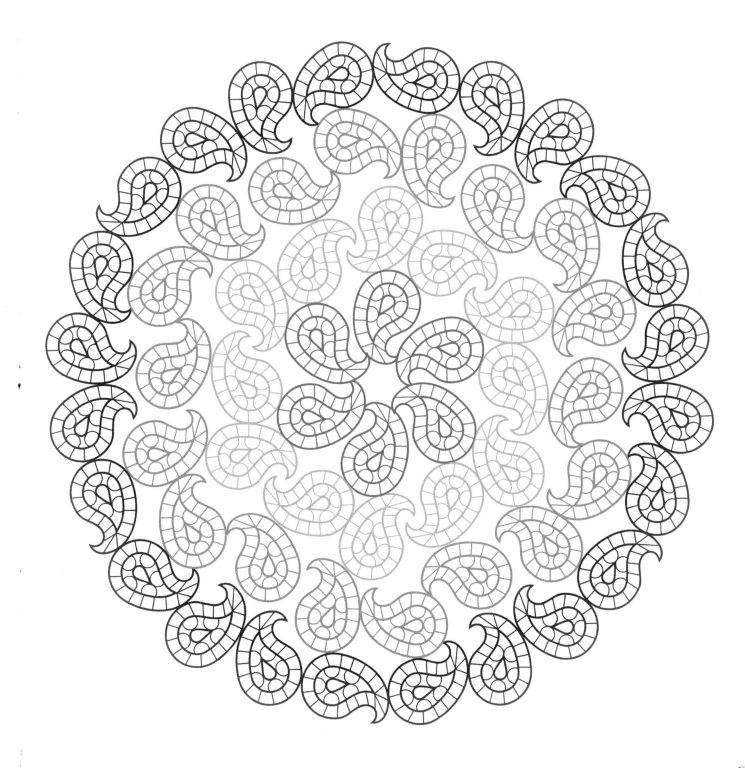

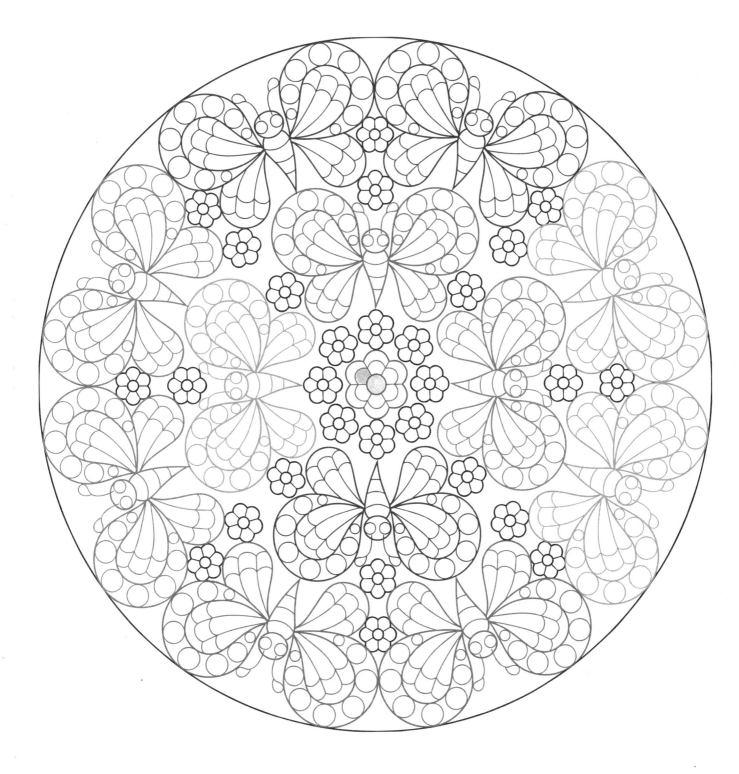

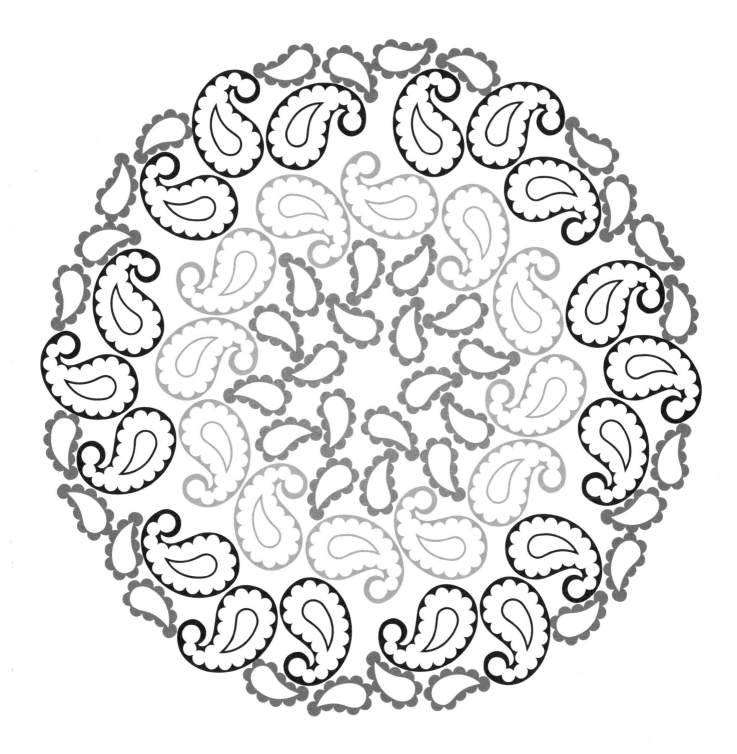

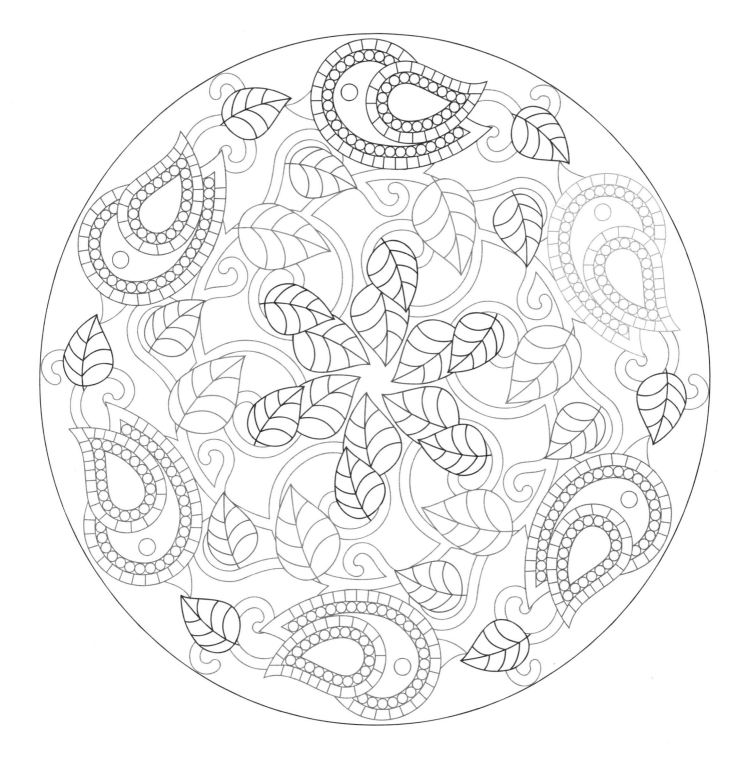

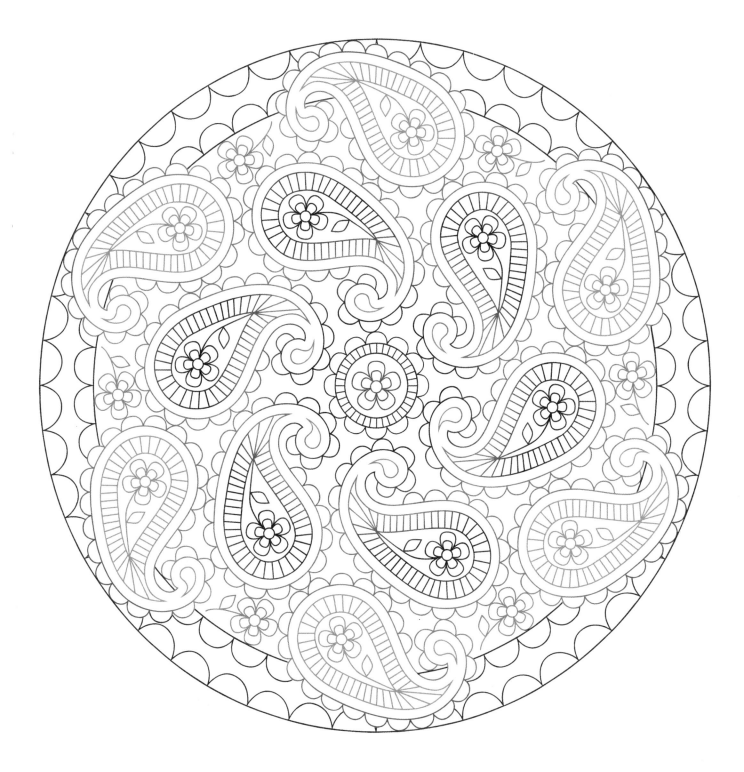

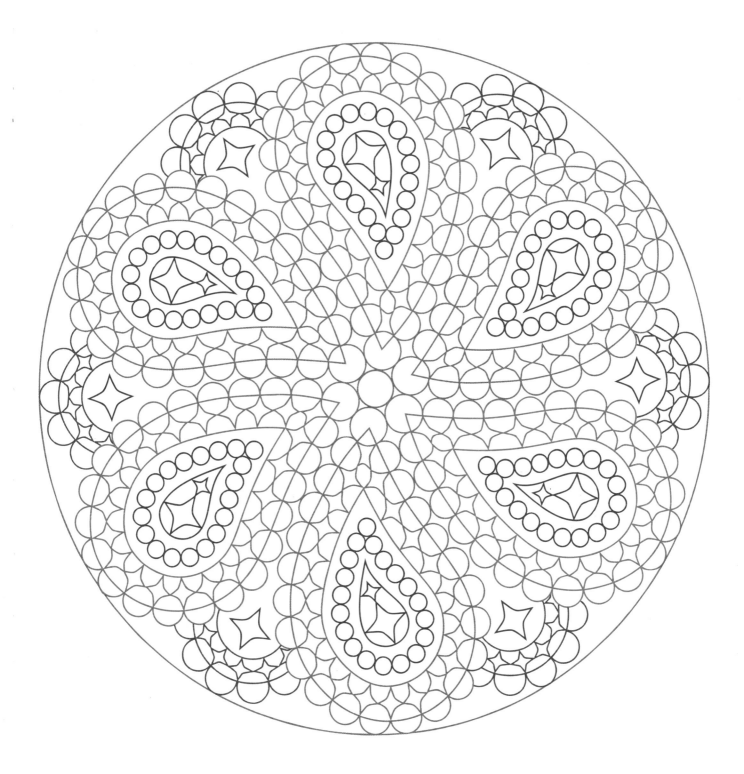

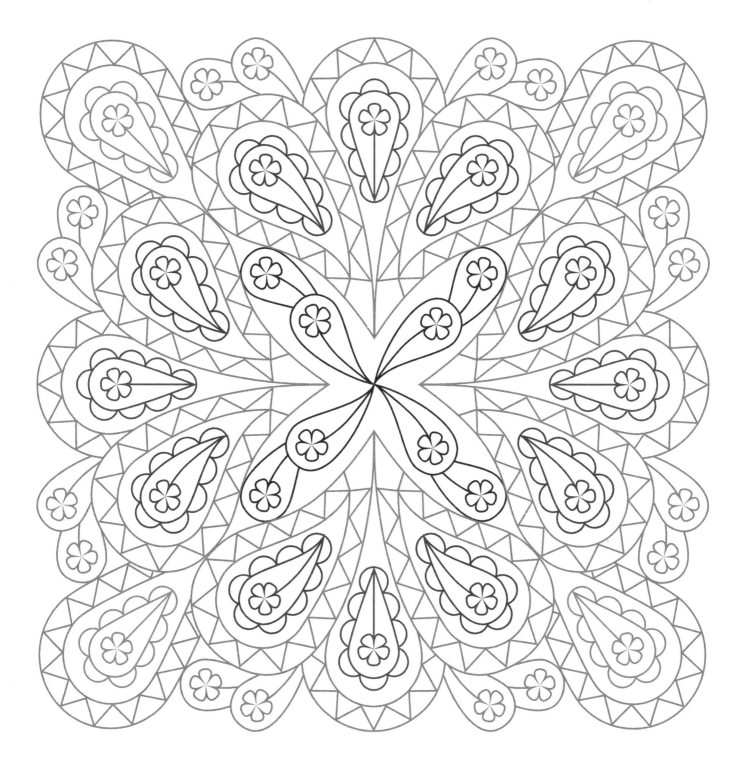

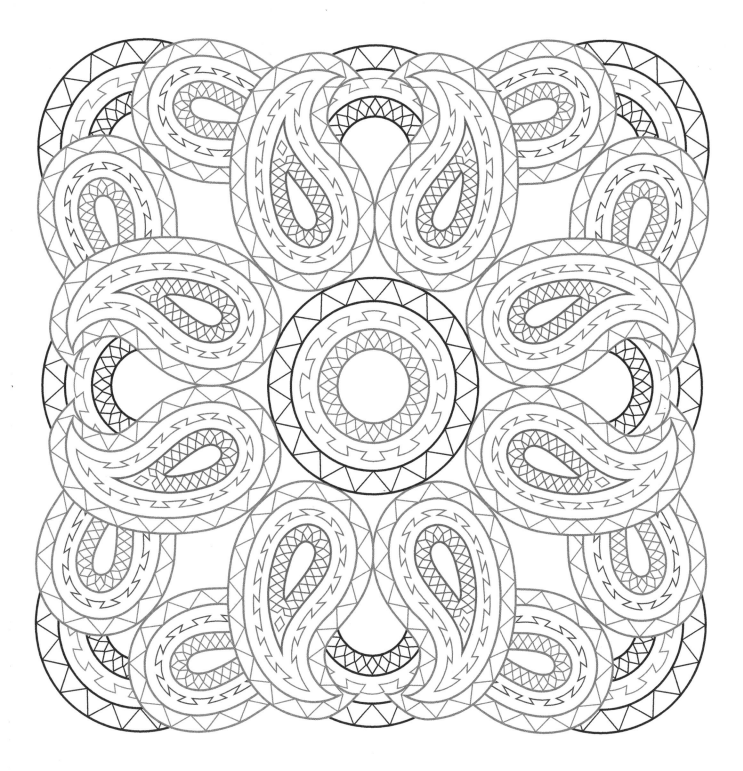

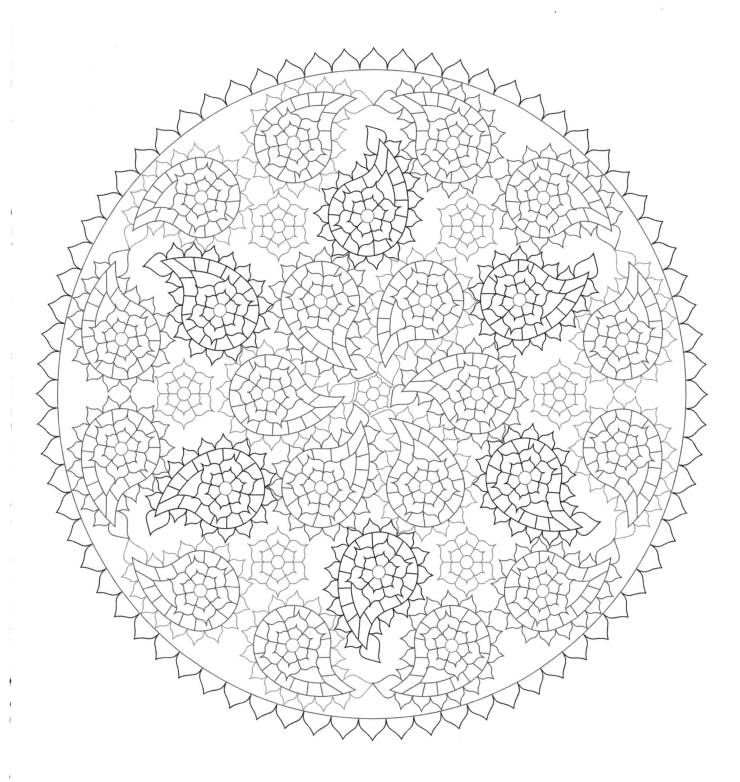

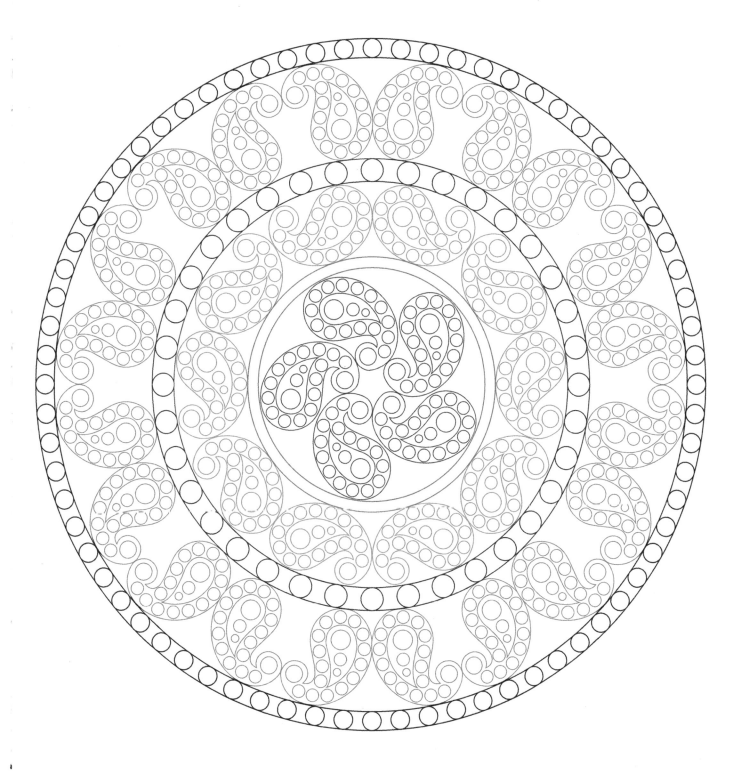

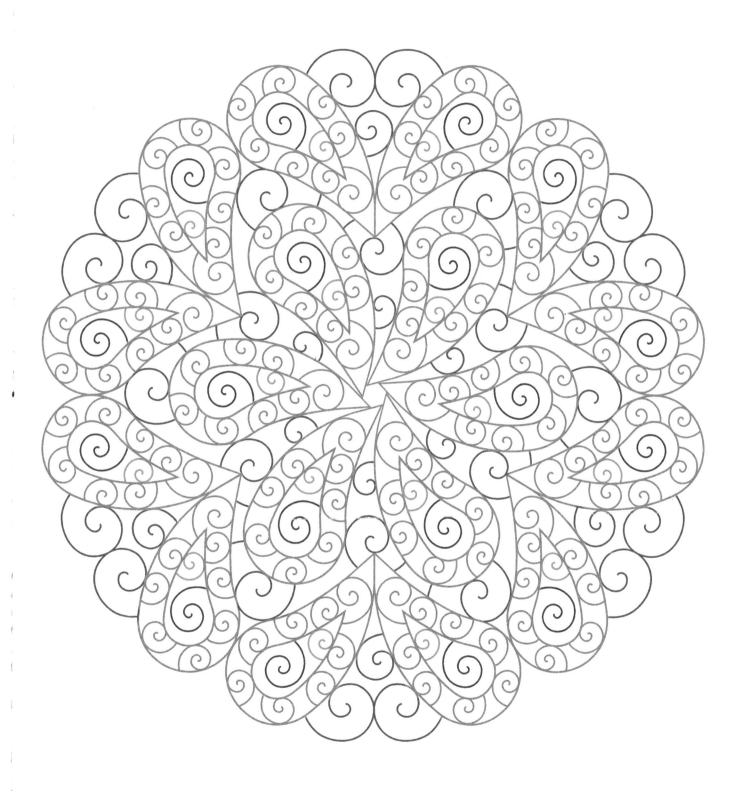

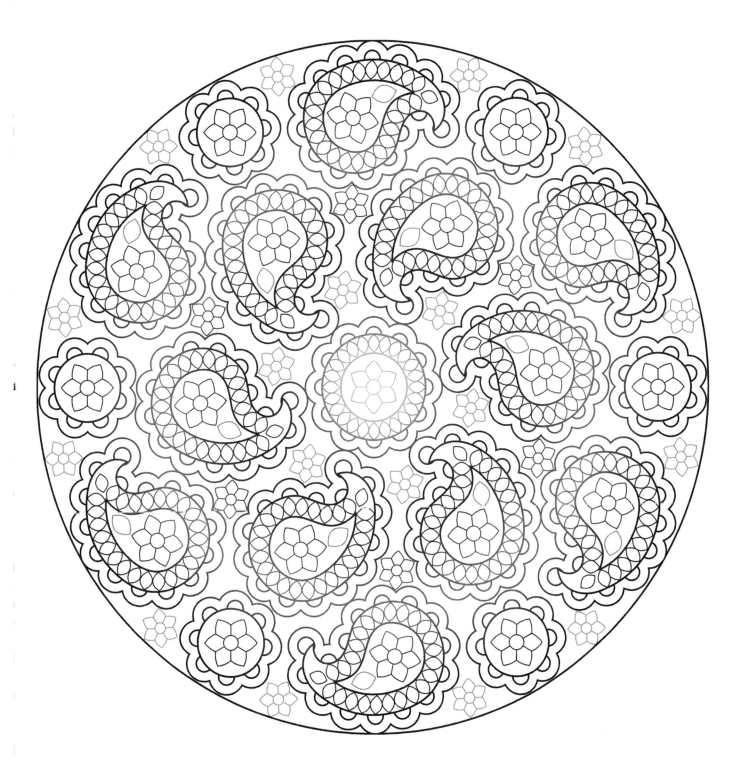

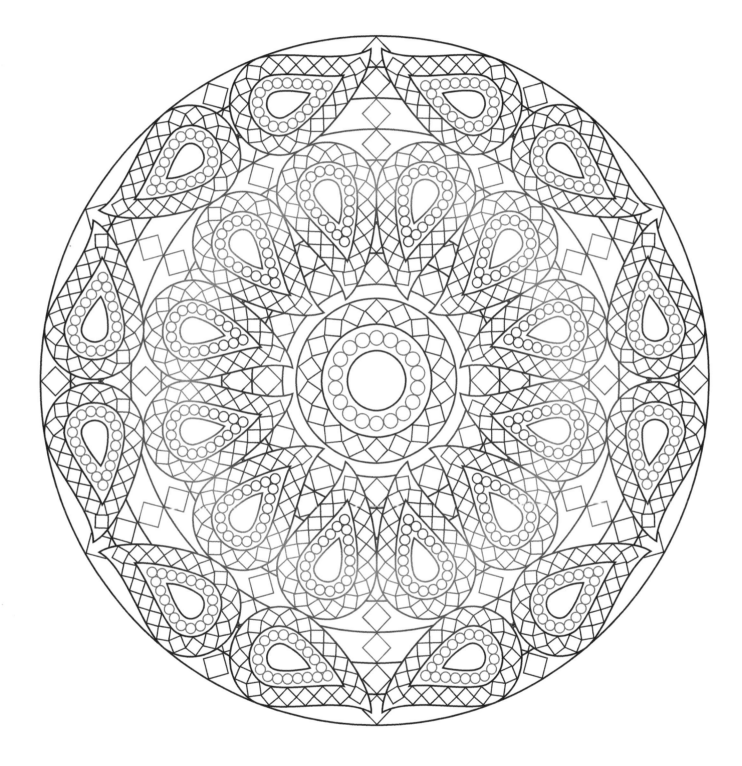

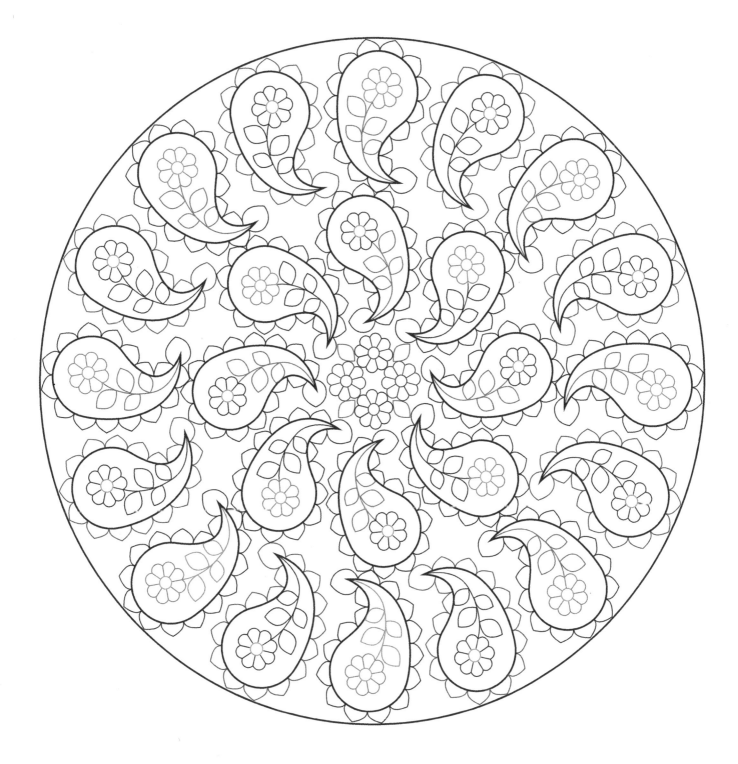

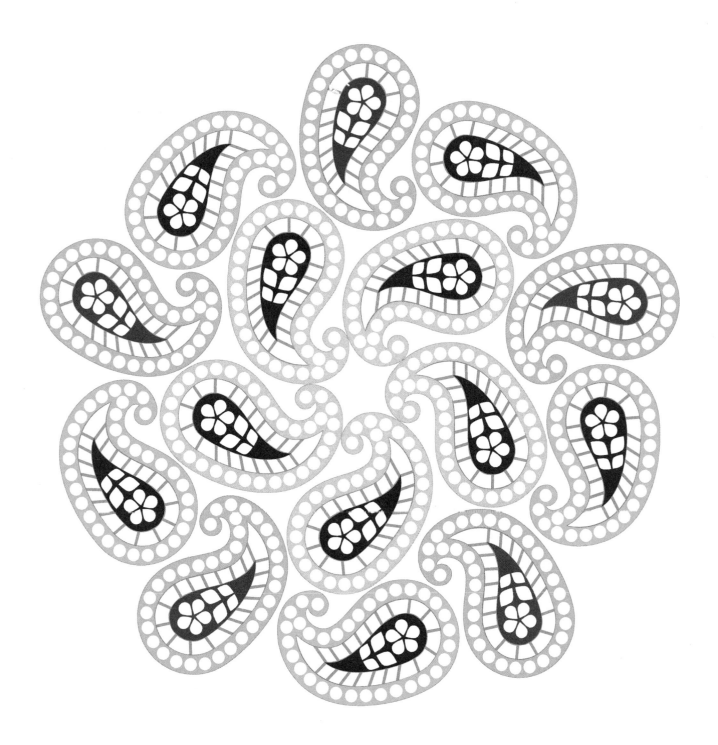

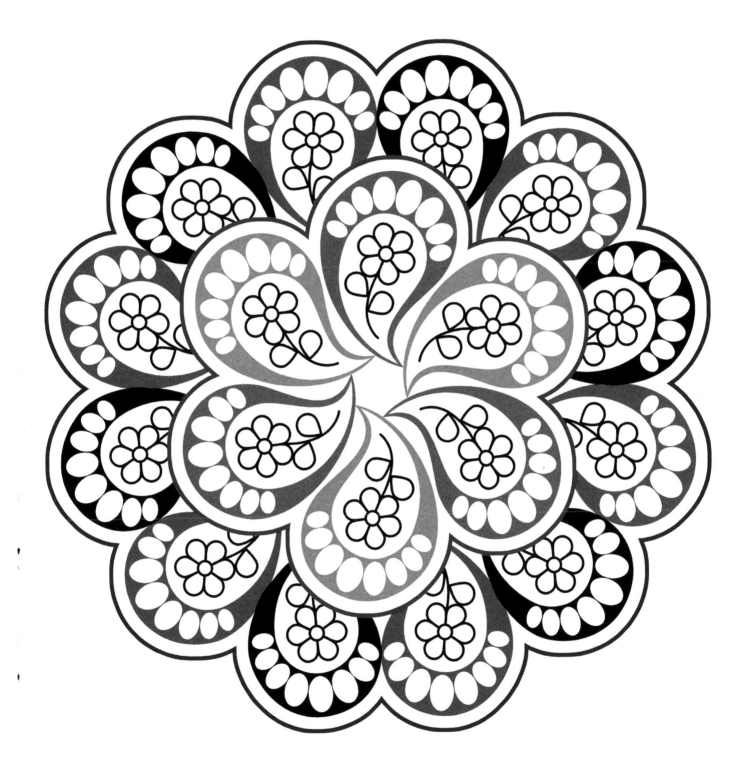

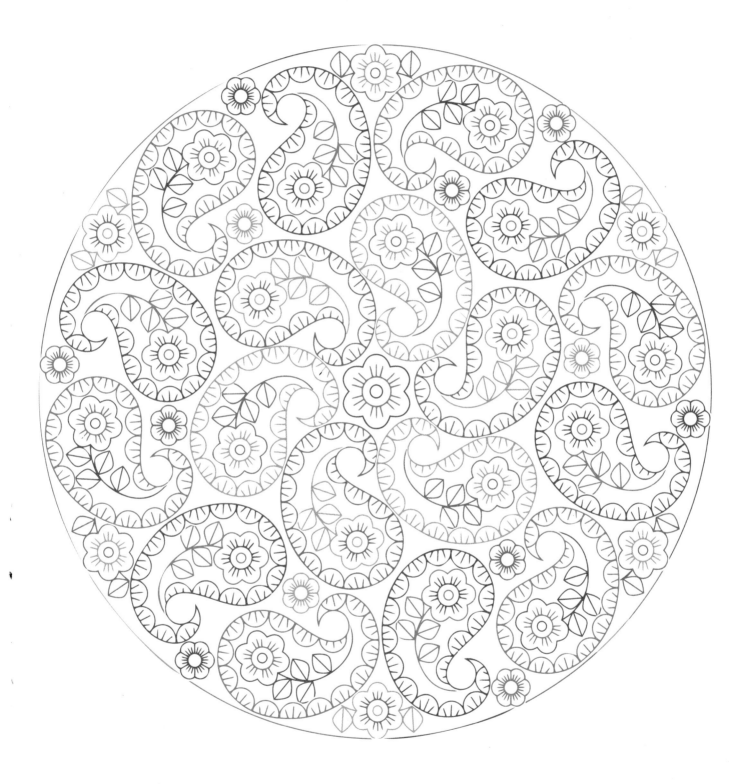

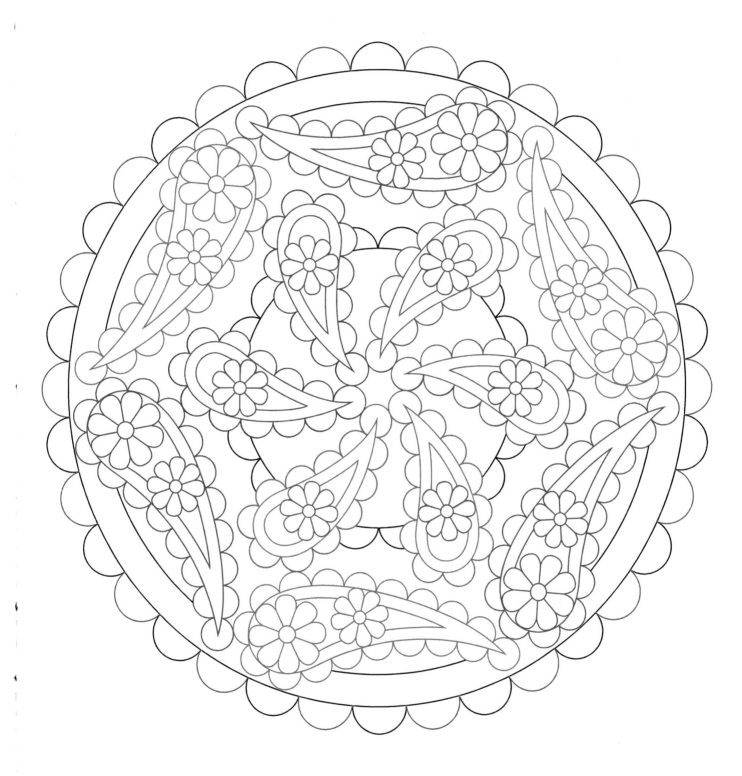

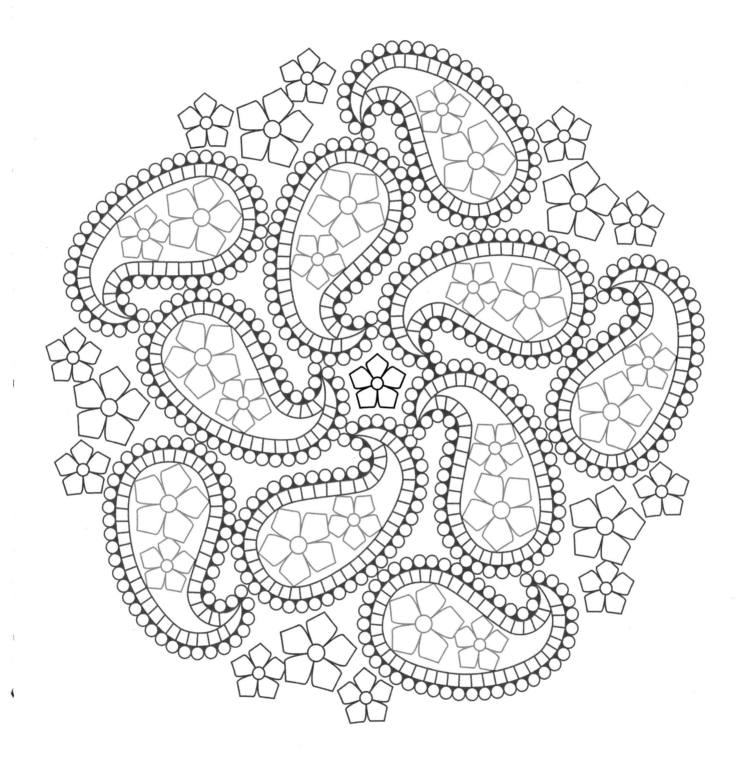

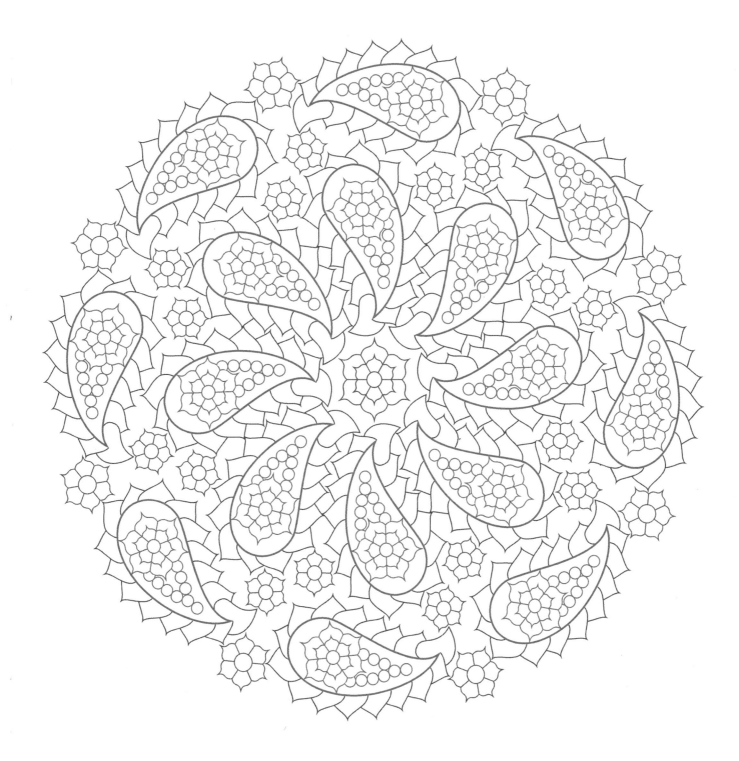

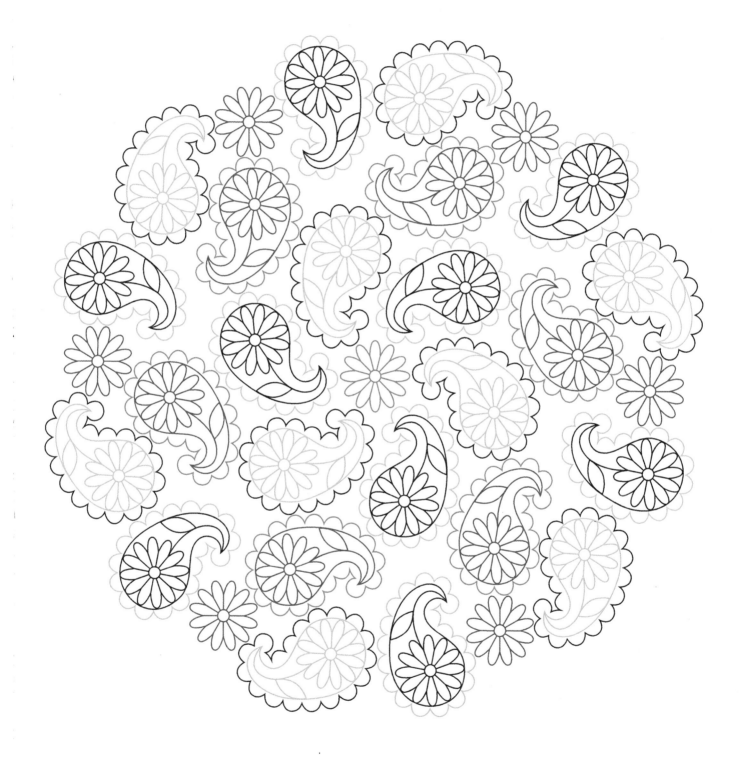

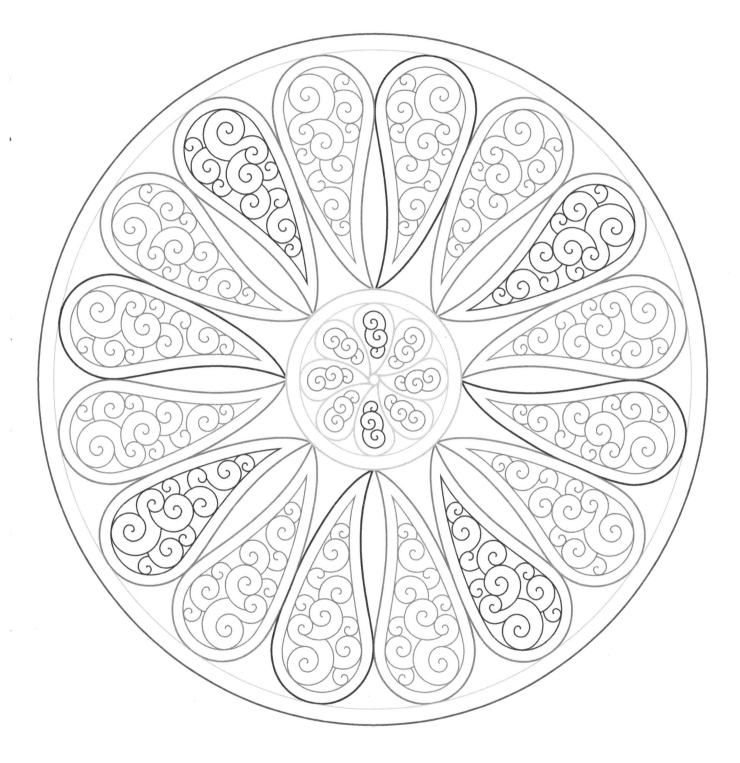

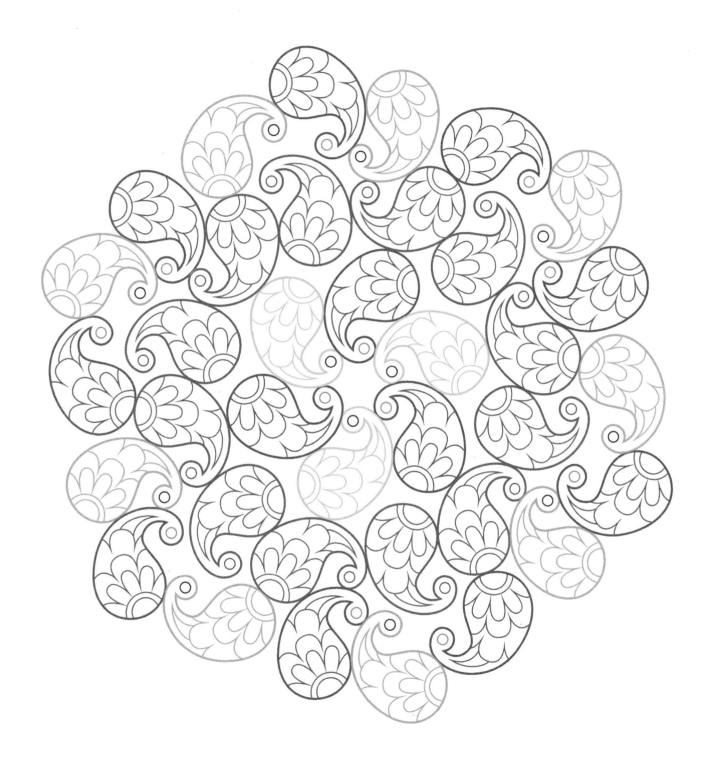